COLCHESTER

HISTORY TOUR
REVISED EDITION

ABOUT THE AUTHOR

Patrick Denney, a Colchester resident, is a well-known local author and one of the leading researchers of Colchester's history. He teaches local and family history classes throughout the region and is a Blue Badge Tourist Guide. He is also secretary of The Colchester Recalled Oral History Group and chairman of the Friends of Colchester Museums.

First published 2019

Amberley Publishing
The Hill, Stroud,
Gloucestershire, GL5 4EP
www.amberley-books.com

Copyright © Patrick Denney, 2019
Map contains Ordnance Survey data
© Crown copyright and database
right [2019]

The right of Patrick Denney to be
identified as the Author of this work
has been asserted in accordance with
the Copyrights, Designs and Patents
Act 1988.

ISBN 978 1 4456 9394 1 (print)
ISBN 978 1 4456 9395 8 (ebook)

British Library Cataloguing in
Publication Data.
A catalogue record for this book is
available from the British Library.

Origination by Amberley Publishing.
Printed in Great Britain.

INTRODUCTION

Colchester is steeped in history and lovers of the town rightly never tire of learning more about its rich and fascinating past. This present compilation of photographs concerns itself with more recent times, particularly from the late Victorian period onwards when early photographers were busy recording everyday life and events in the town. And, of course, it is entirely thanks to their endeavours that a book such as this can be made available.

But what makes this book different from my previous title, *Colchester Through Time*, upon which this work is largely based, is the fact that the illustrations have been presented in the form of a walking tour of the town, complete with an accompanying location map. Thus the reader, if so desired, can physically follow the route of the tour visiting the many sites and views presented.

More than sixty specially selected photographs have been included to illustrate the tour, some of which are presented in both a 'then and now' format allowing the reader to see how various changes have taken place over the years. Collectively, the images provide a fascinating glimpse into how Colchester has changed and developed over the last hundred or so years. In a few cases these changes have been slow and hardly noticeable, whereas in others the pictures reveal a town that has altered and developed almost beyond recognition.

In summary, the book provides a graphic record of changing street scenes, development in transport, evolving fashions and of how individual buildings have developed and altered over the years.

It is hoped that the book will be of interest to people from all walks of life, but particularly to those who have an interest in the ongoing history and heritage of Colchester.

Patrick Denney

KEY

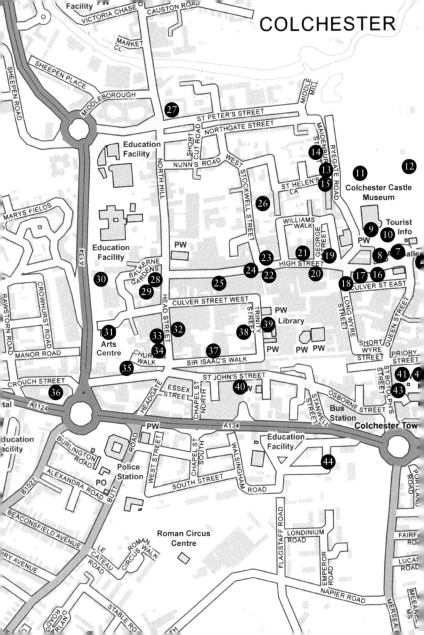

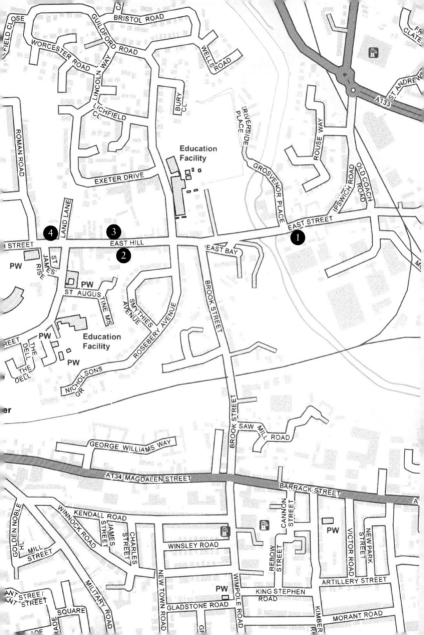

1. THE SIEGE HOUSE

This 1905 view of East Bay is a little unusual in that the old Siege House, seen on the right, still retains its external covering of plaster. However, shortly after this picture was taken the plaster was removed, as was the fashion at the time, exposing the studwork of the timber framing. The building is currently being used as a restaurant. Also look out for the numerous bullet holes in the building's timberwork, which date from the time of the Siege of Colchester in 1648.

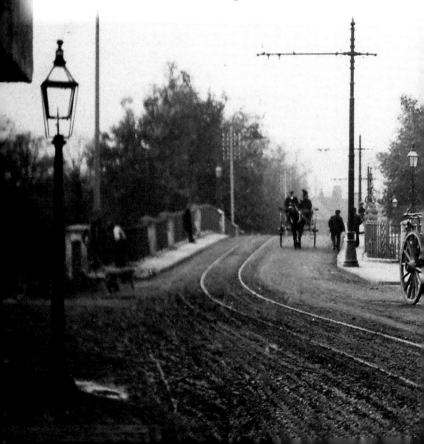

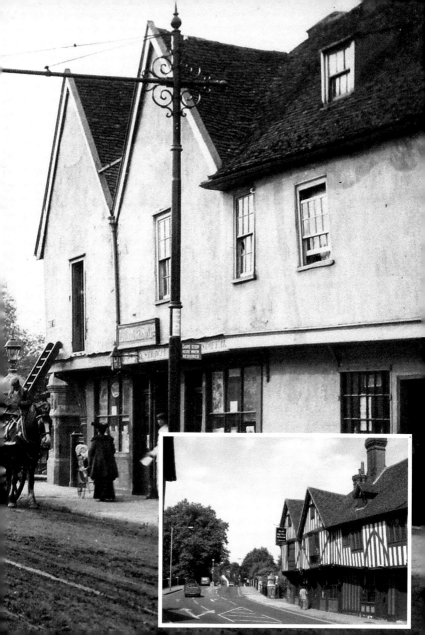

2. EAST HILL RISING TOWARDS THE TOWN CENTRE

There is not a motor car in sight in this 1912 view looking up East Hill. How on earth did they manage? This is one of two approaches to the town that rises fairly steeply to the summit. If a horse-drawn vehicle was pulling a heavy load up the hill, the driver would ensure that the ascent took place in several stages.

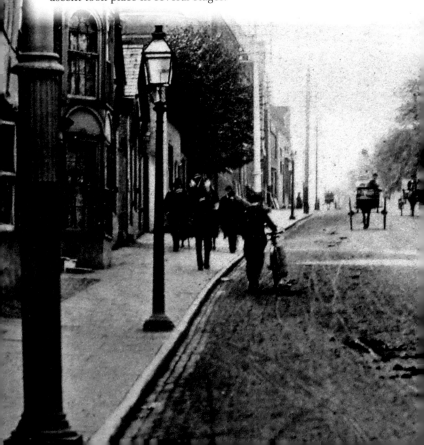

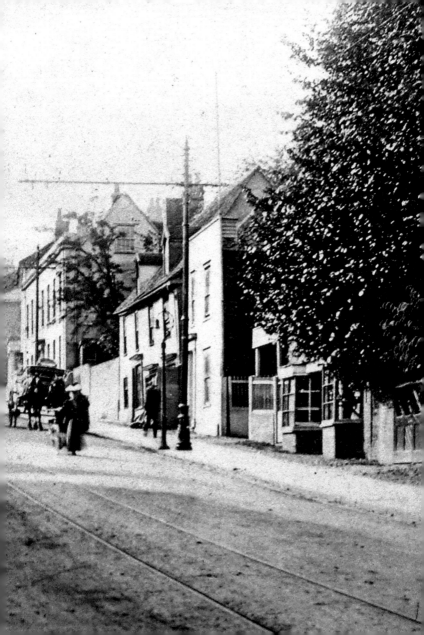

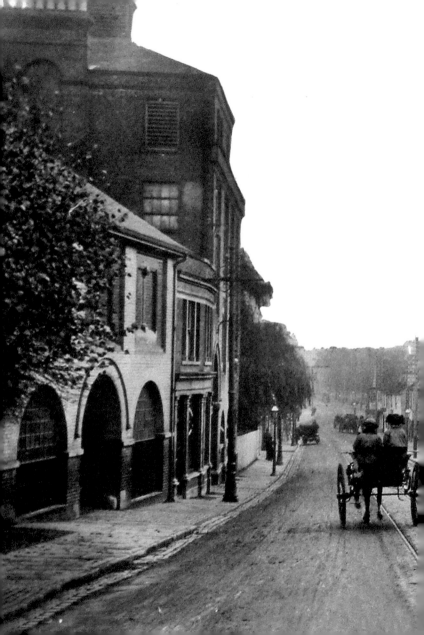

3. EAST HILL WITH HORSE AND TRAP

A horse and trap makes its way down East Hill around 1910. No doubt the driver is being careful to avoid getting his wheels caught in the tramlines. The large building on the left was part of a brewery complex, which has since been converted into housing accommodation. Although the tramway disappeared in 1929, the street has retained some of its old-world charm.

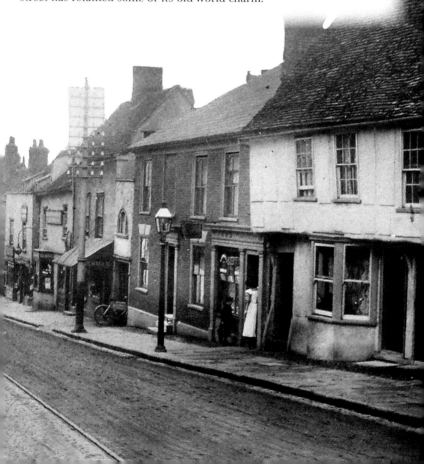

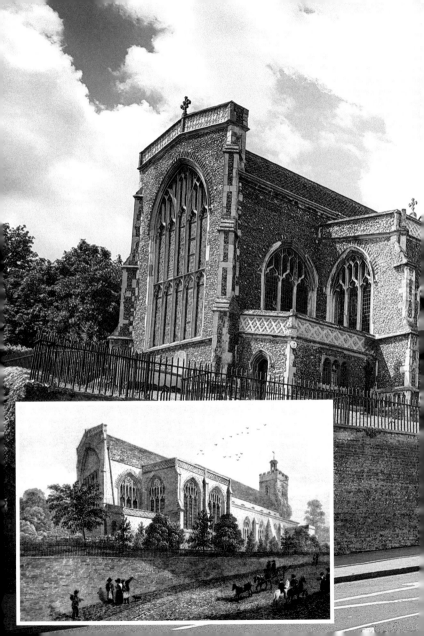

4. ST JAMES' CHURCH

This modern view of St James' Church on East Hill shows that very little has changed since the older picture was published in 1824. It is the largest of the town's medieval churches and only one of two in the town centre still open for worship.

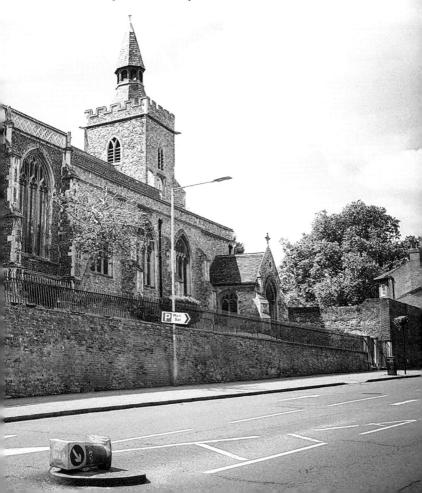

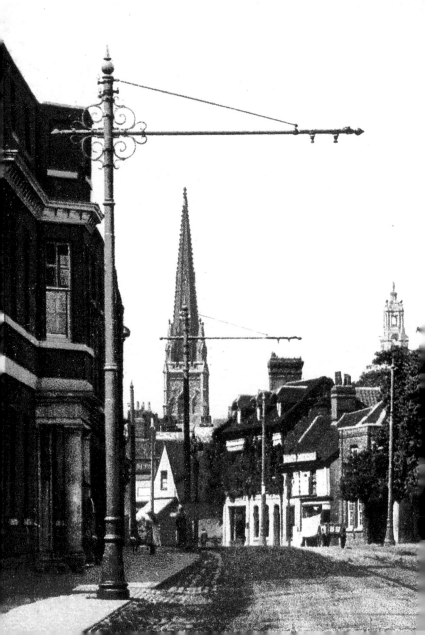

5. LOWER HIGH STREET LOOKING WEST FROM THE TOP OF EAST HILL

The gabled building on the right of this view from the early 1900s still remains, although the white-fronted building beyond was demolished in the 1930s. The building to the left of the picture is now the Minories Art Gallery, but was once the home of a prosperous eighteenth-century cloth merchant named Thomas Boggis. Note also the tall spire of St Nicholas' Church, which was demolished in the 1950s.

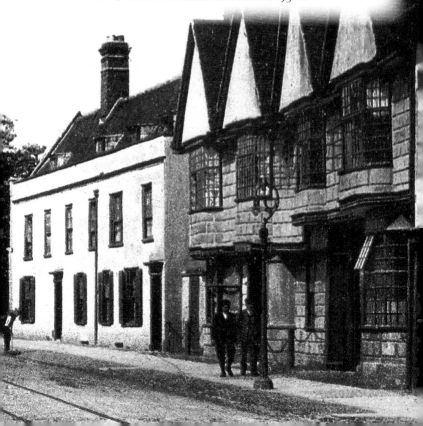

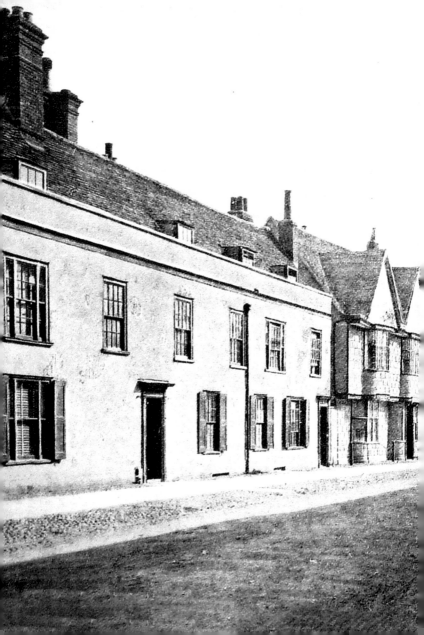

6. LOWER HIGH STREET LOOKING EAST

In this view of the same row of buildings we are looking in the opposite direction towards East Hill. The building on the immediate left was known as Frere House and was built predominately in the seventeenth century. It occupied the space between the Gate House (with gabled roof) and Hollytrees, before being demolished in the 1930s. As the modern view reveals, the space is now used as a flower garden dedicated to Colchester's twinning with the German town of Wetzlar.

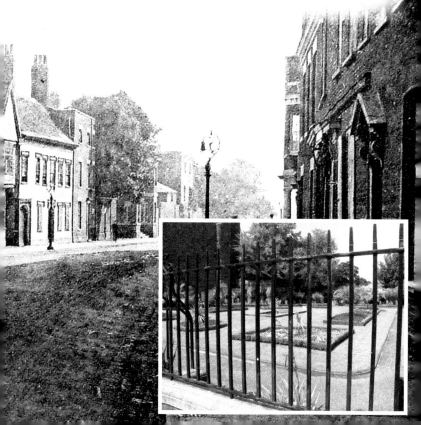

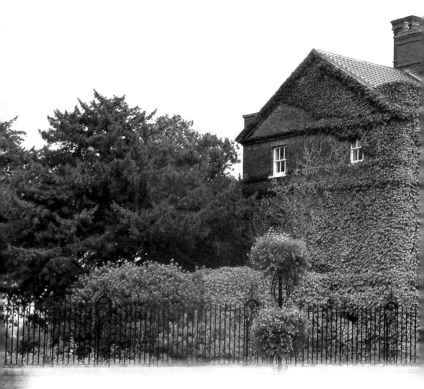

7. HOLLYTREES MUSEUM

According to the architectural historian Nikolaus Pevsner, this is 'the best eighteenth-century house in Colchester'. The building stands just inside Castle Park and houses a fine collection of toys, costume and home furnishings, largely from the Victorian period and early twentieth century. The building first opened as a museum in 1929, but in recent years the display areas have been upgraded and modernised. The museum is also currently home to the Visit Colchester Information Centre.

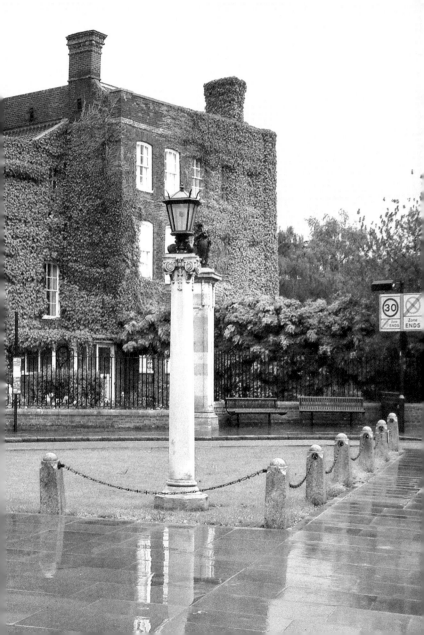

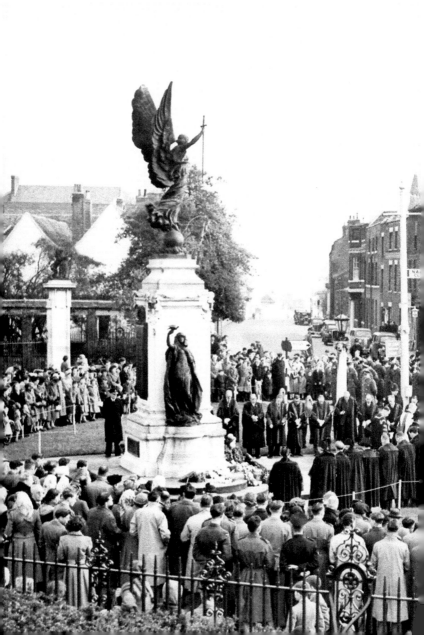

8. THE WAR MEMORIAL

The war memorial dominates the entrance to Castle Park at the lower end of the High Street. The monument, which incorporates bronze statues of Victory, Peace and St George, was erected in 1923 and remains a focal point for remembrance services at various times of the year. In this view, dating from the 1940s, a large crowd has gathered for the main remembrance service.

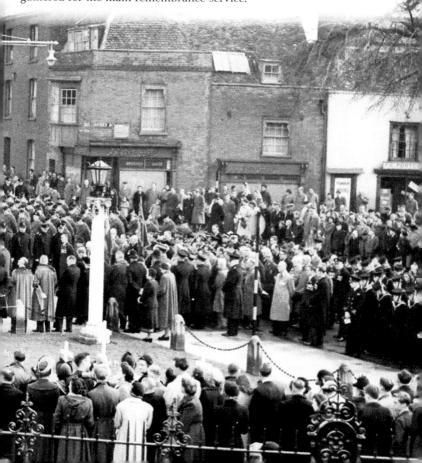

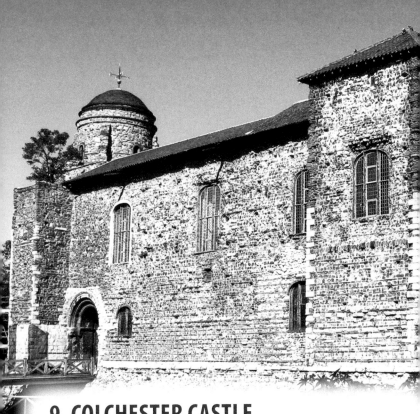

9. COLCHESTER CASTLE

Colchester Castle was built during the reign of William the Conqueror and is the largest surviving Norman keep in Europe. Building work probably began in the early 1070s and was completed by around 1100. The building is constructed mainly of recycled Roman brick and septaria and sits on top of the surviving foundations of the former Roman Temple of Claudius, which was erected here following the emperor's death in AD 54.

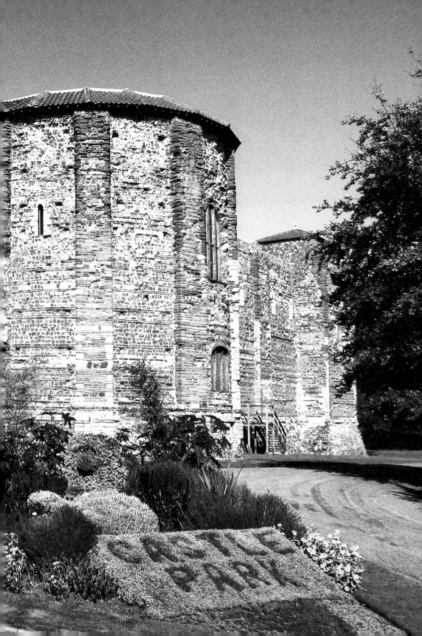

10. FISH POND IN CASTLE PARK

This charming view of young children peering into the fish pond in Castle Park dates from the 1920s. The pond appears to be newly constructed, as seen by the newly planted flower borders.

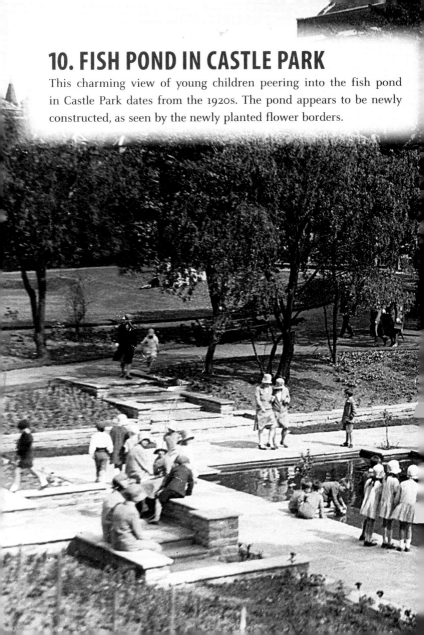

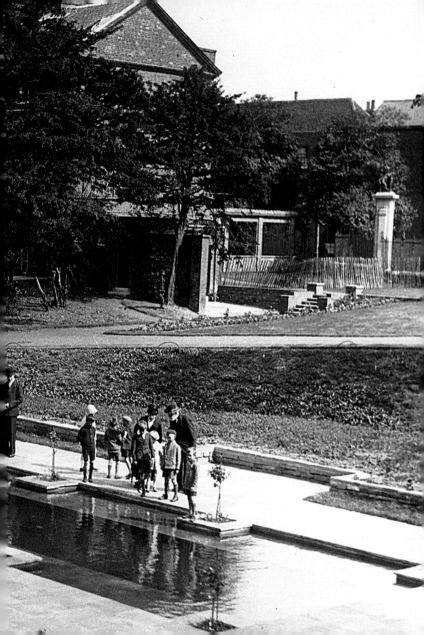

11. LAWNS AND FLOWER BORDERS, CASTLE PARK

This picture of Castle Park was taken shortly after it opened in 1892 and shows a group of workmen tending the lawns. A number of sapling trees have been planted and there is an unobstructed view over Lower Castle Park. Today those trees have reached maturity and form part of a collection of more than 500 trees and 5,000 shrubs in the modern setting.

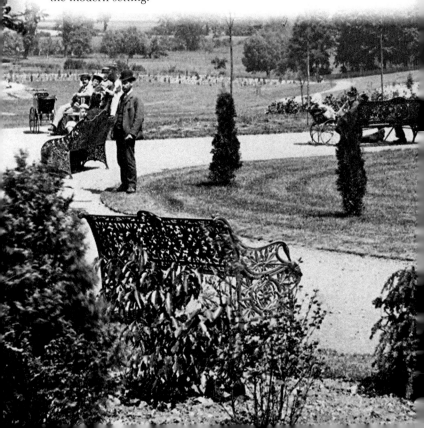

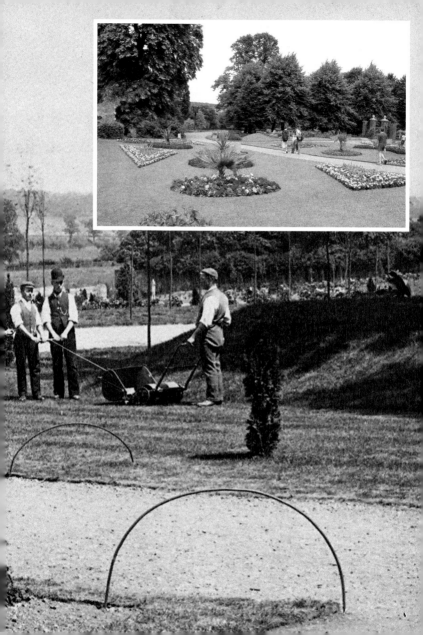

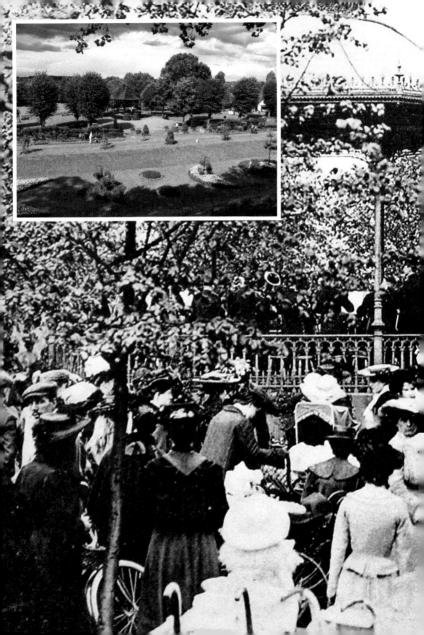

12. BANDSTAND IN CASTLE PARK

In this Edwardian view of the bandstand in Castle Park, a military band is playing to a large assembled audience. The bandstand is still a venue for open-air events, while in the Lower Castle Park large-scale rock and classical concerts have become a regular summer feature.

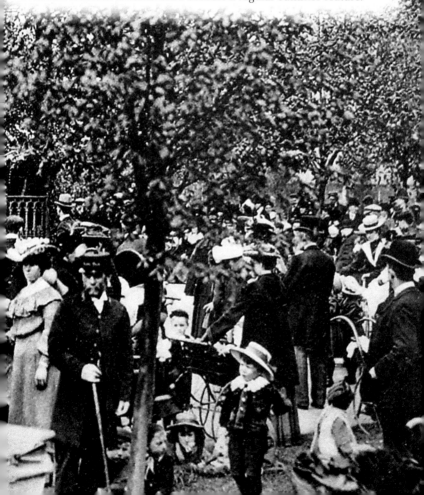

13. ST HELEN'S CHAPEL

St Helen's Chapel was first recorded in 1096/97. According to local legend the building was founded by the Empress Helena (the town's patron saint) in the third century AD. The legend also says that Helena was the daughter of King Coel of nursery rhyme fame and that her son, Constantine the Great, was born in Colchester. Whatever the truth of the legend, the building certainly had an early foundation as it stands on the site of a former Roman theatre (see Roman Theatre building further up Maidenburgh Street).

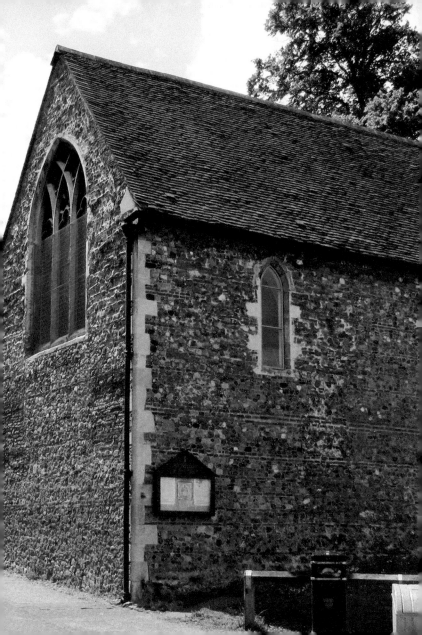

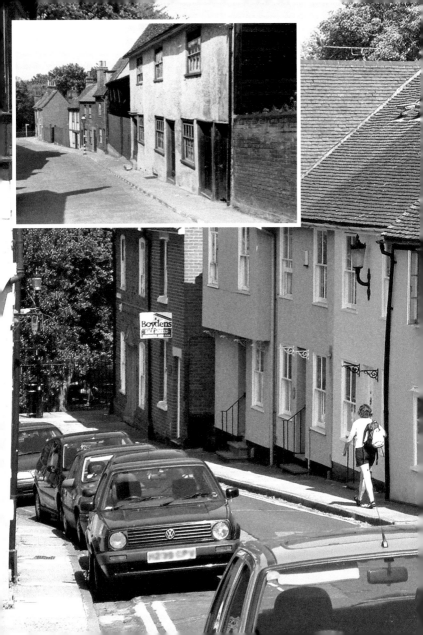

14. ARCHITECTURAL SUCCESS IN THE DUTCH QUARTER

The regeneration of the town's Dutch Quarter in the 1950s proved to be a major architectural success story. These two opposing views of the east side of Maidenburgh Street show that the houses have been restored to a high standard, adding vigour and life to this part of the town. The Dutch Quarter is so named after the influx of Flemish refugees who began to settle in the area from the late sixteenth century.

15. MAIDENBURGH STREET

Two further views of Maidenburgh Street highlighting the successful modernisation of this part of town. The timber-clad building to the right has changed almost beyond recognition with the addition of new dormer windows, the repositioning of the front door and a rendered exterior. The earlier picture dates from the early 1900s, while the modern view is from 2004.

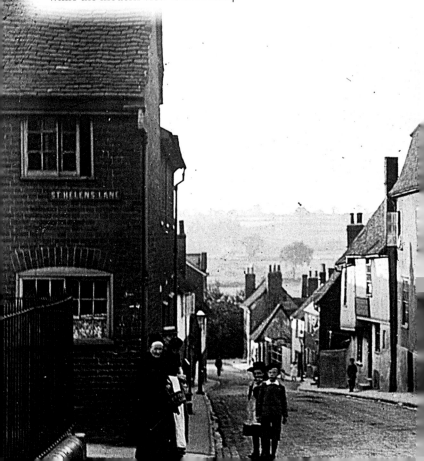

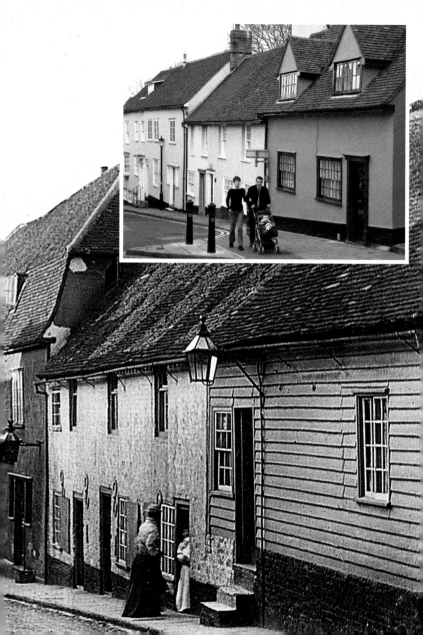

16. THE TWIN TOWERS OF ST NICHOLAS' CHURCH AND THE TOWN HALL

This 1930s scene is dominated by the tall Gothic spire of St Nicholas' Church, which was erected in the 1870s to replace a former building and demolished in the 1950s. Also visible in the background is the tower of the new town hall, which opened in 1902.

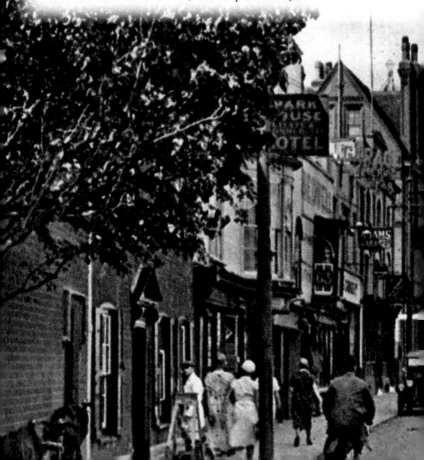

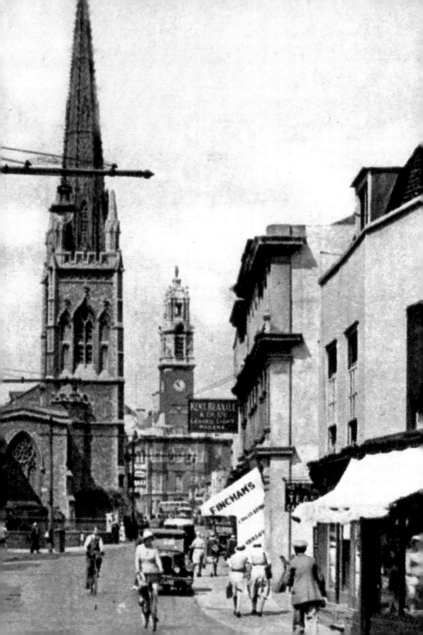

17. ST NICHOLAS' CHURCH, WITH 'FRYING PAN' CLOCK

This charming view of the High Street dates from 1831 and shows the ruined St Nicholas' Church, with its 'frying pan' clock. The former Church of St Runwald can be seen at the far end of the street, which, until its removal in 1878, created a bottleneck at this juncture. Despite the street being the A12 of its time, the people depicted seem happy enough to wander about the road and, in one case, sit comfortably upon a stool!

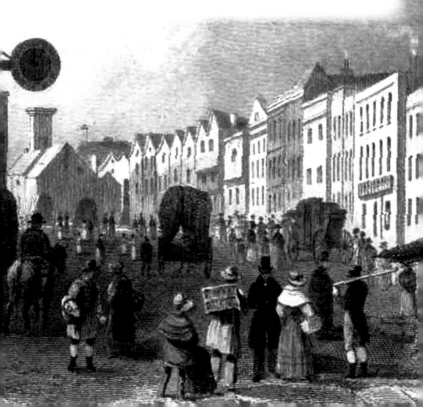

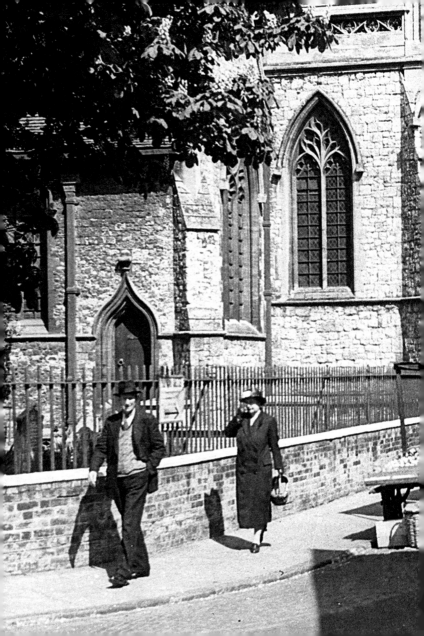

18. MARKET STALLS IN ST NICHOLAS STREET

Market day in St Nicholas Street, pictured around 1940. Traditionally, this is where you could buy shellfish and the like, although it is not clear from the picture what is being sold on this occasion. Also visible on the far side of the High Street is George Farmer's ironmongers, which has only closed in recent years after trading here since the early 1830s.

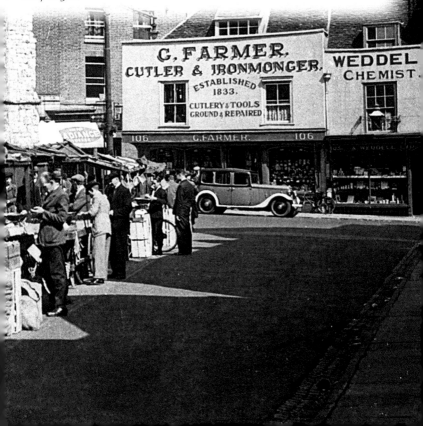

19. CONTRASTING VIEWS OF HIGH STREET

Two contrasting views of the north side of High Street taken around 125 years apart. In the distance in the earlier view is the old Victorian town hall, which was demolished in the late 1890s. Note the wide pavements and the alfresco café culture that has developed on the right-hand side of the street in modern times.

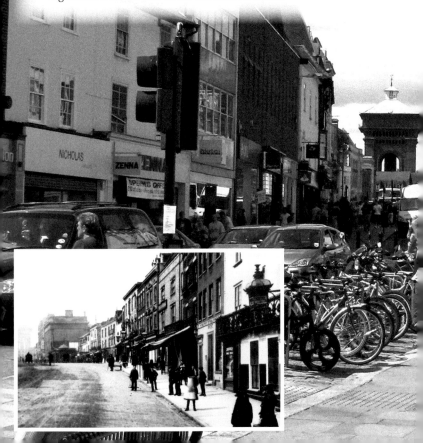

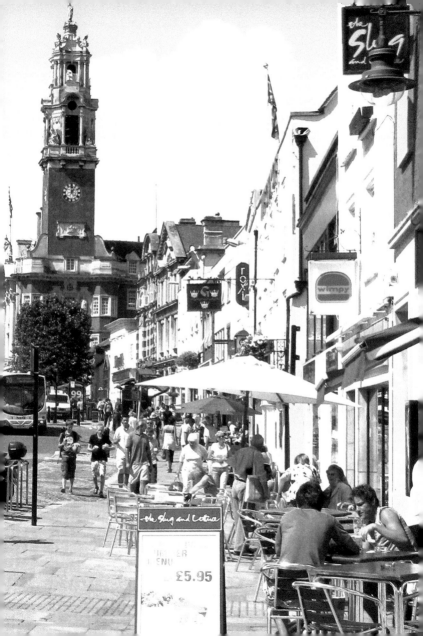

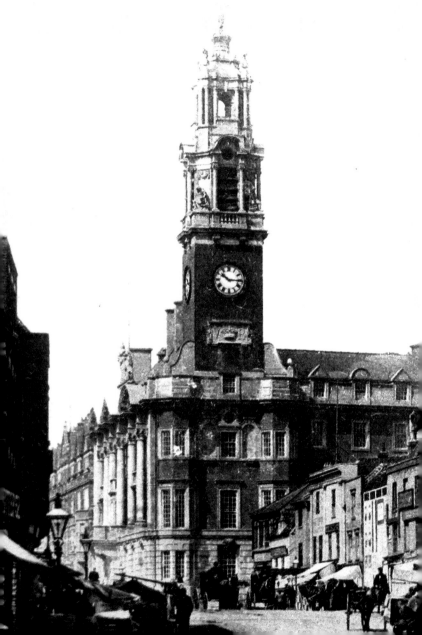

20. HIGH STREET AND THE TOWN HALL

Colchester High Street looking west from near Maidenburgh Street in 1902. Dominating the scene is the newly erected town hall, which opened in May 1902 at a cost of about £55,000. Within a year or so of this picture being taken, motor traffic and electric trams had begun to revolutionise local transport.

21. THE RED LION

The Red Lion has a long history as a coaching inn. It dates back to the late fifteenth century when the building was the residence of the Howard family, later dukes of Norfolk. When it first became an inn in 1515 it was known as the White Lion, but later underwent a change of colour. The earlier of these two views may have been taken sometime before 1884, for this is when the proprietor of the time, William Fletcher, sold out to Daniell's Brewery.

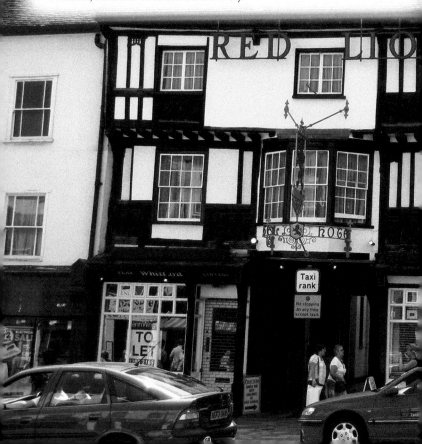

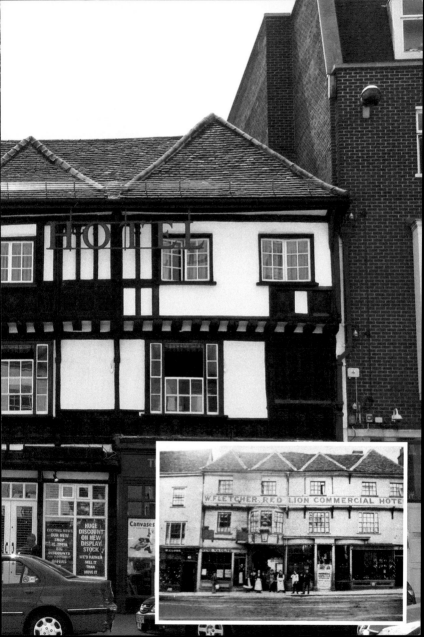

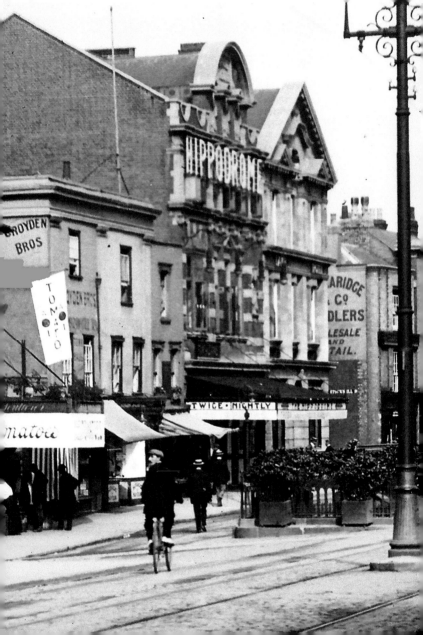

22. MUSIC HALL STARS

The Grand Theatre (later renamed the Hippodrome and now a nightclub) opened its doors to the Edwardian public on Easter Monday 12 1905. From here on it was vaudeville all the way, with the likes of Marie Lloyd, Harry Lauder and Vester Tilley performing to packed houses twice nightly. Even the comedian Charlie Chaplin trod the boards at the Hippodrome before moving to America. The building immediately to the right of the theatre is the Lamb Hotel, currently known as After Office Hours.

23. AN EDWARDIAN VIEW OF THE HIGH STREET

This High Street scene from 1905 has all the flavour of the Edwardian era. The street is full of carrier carts and wagons, suggesting that this was probably market day. Tramcar No. 11 can be seen en route to the Hythe and the building on the right of the street is displaying a temporary sign advertising the opening of John Sainsbury's first store in the town.

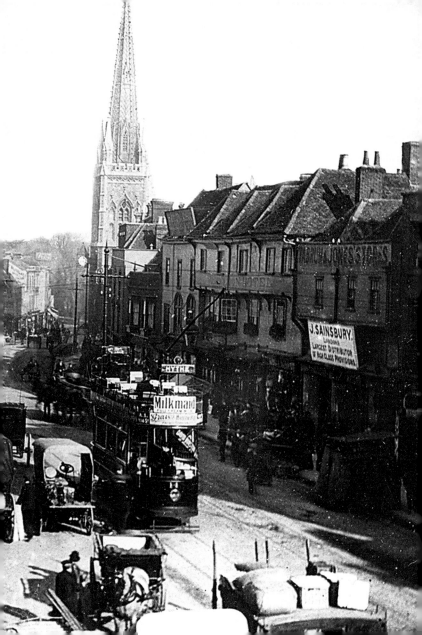

24. THE EDWARDIAN HIGH STREET AND JUMBO

In this Edwardian view of the High Street we are looking west towards 'Jumbo', the Victorian water tower, which is seen in the background. To the right of the picture a Hansom cab can be seen parked in front of the old underground gent's lavatory. The picture dates from around 1903 shortly before the arrival of the tramway system.

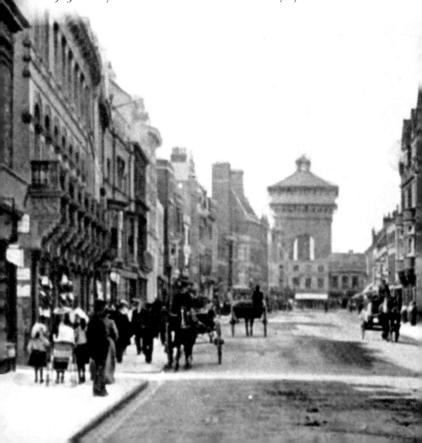

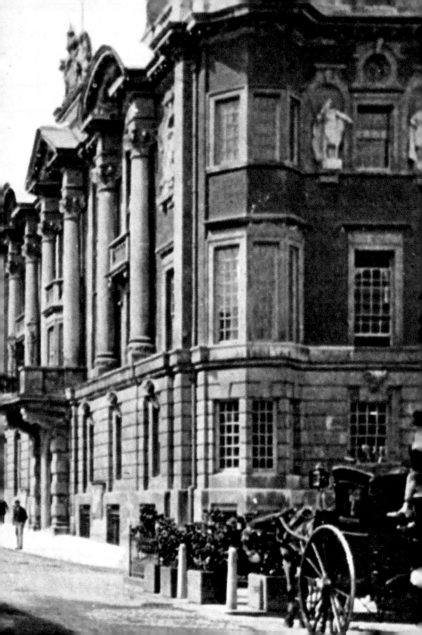

25. THE CUPS HOTEL AND TOWN HALL

This black and white picture from the 1920s shows the splendid brick façade of the Cups Hotel, which was sadly demolished in the late 1960s. Adjoining the Cups is the current town hall building, which opened in May 1902. The contemporary photograph shows the rather nondescript office block that replaced the Cups Hotel.

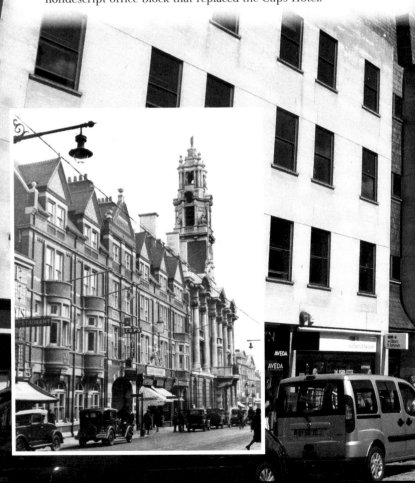

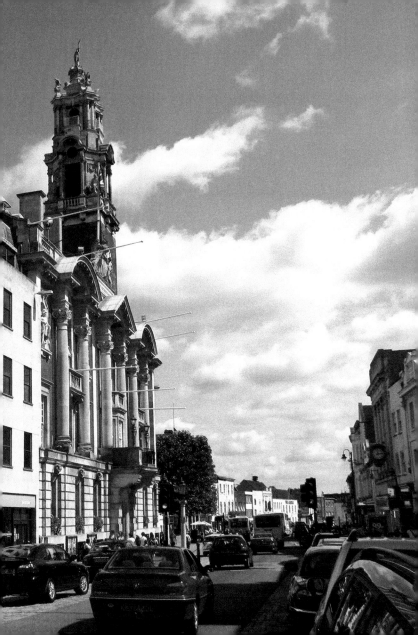

26. ST MARTIN'S CHURCH

The oldest part of St Martin's Church is the tower, which dates from the Norman period, although most of the fabric is medieval. The tower stands no higher than the nave, a result of damage caused by cannon fire during the Siege of Colchester in 1648. Note the recycled Roman bricks in the tower structure. Inside the now-redundant church are several interesting features including, in the tracery of the east window, a representation of the Hebrew Tetragrammaton (God's name, which is usually articulated as Jehovah).

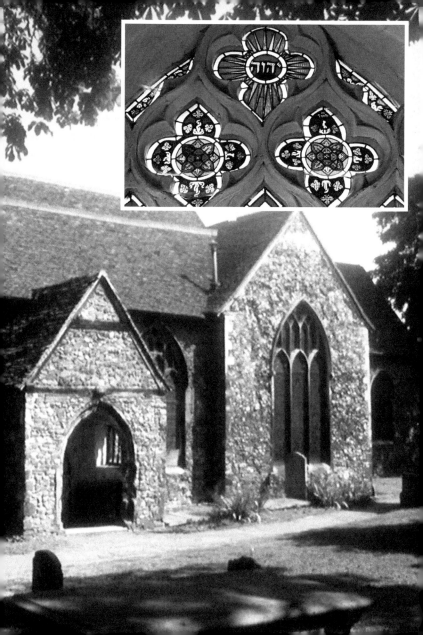

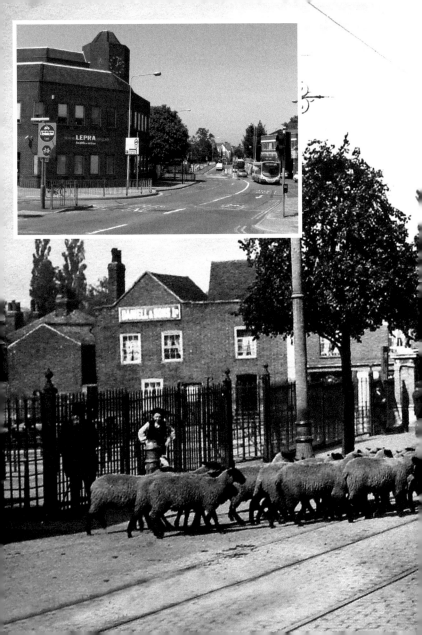

27. MARKET DAY

In this charming scene from 1913 a flock of sheep are being driven from the cattle market at Middleborough in a northerly direction out of town, while a tram can be seen en route to Colchester North station some half a mile away. In the modern photograph the scene is almost unrecognisable. The market has gone and the site is now dominated by a large office complex.

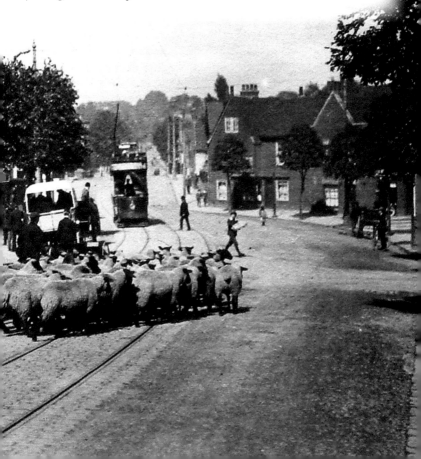

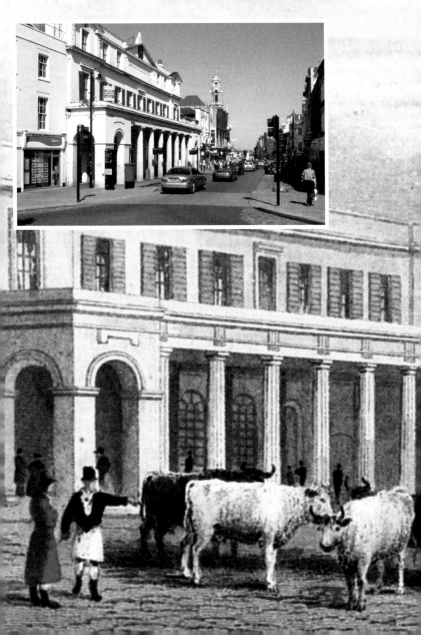

28. HIGH STREET AND FIRE OFFICE

This early view of the High Street dates from 1831 and is seen looking east from near the top of North Hill. The cattle in the foreground are a reminder that the old cattle market was located in the High Street until the early 1860s. The colonnaded building, known locally as the Fire Office, dates from 1819/20 and was built to serve as both a corn exchange (lower floor) and a fire insurance office. The modern photograph was taken in 2003.

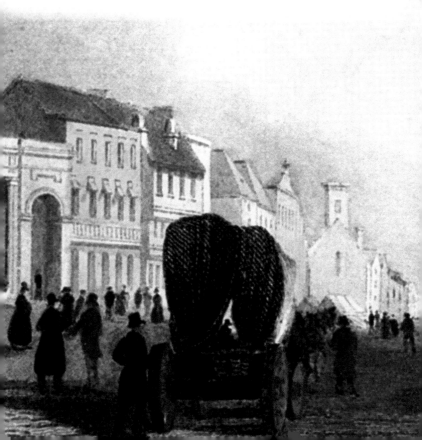

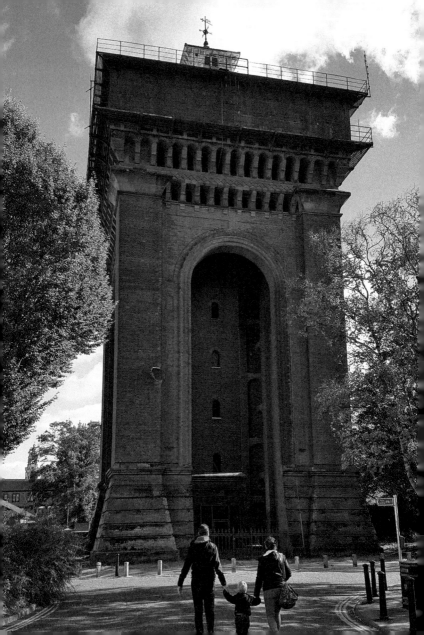

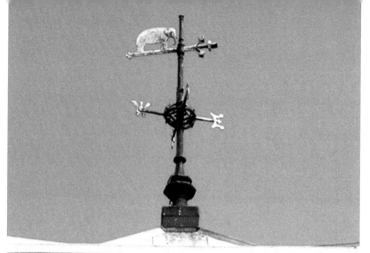

29. WATER TOWER 'JUMBO'

The large Victorian water tower was built in 1882 and is known locally as Jumbo. It is named after a famous elephant of the time at London Zoo, which was sold, amid public outcry, to Barnham and Bailey's travelling circus in America. The Revd John Irvine, who lived in his rectory on the site of the present Mercury Theatre, was not happy about the giant structure being erected at the bottom of his garden and described the 'monstrosity' as a 'jumbo', and the name stuck. Note the brass elephant depicted on the tower's weathervane.

30. THE BALKERNE GATEWAY

This is the oldest surviving Roman gateway in Britain. In Roman times the gateway extended across the entire area now covered by the Hole in the Wall public house and included two large central carriageways with a pedestrian footway on either side. It also served as the main entrance to the town. Step down into the former guardroom on the left and take a close look at the original facing brickwork.

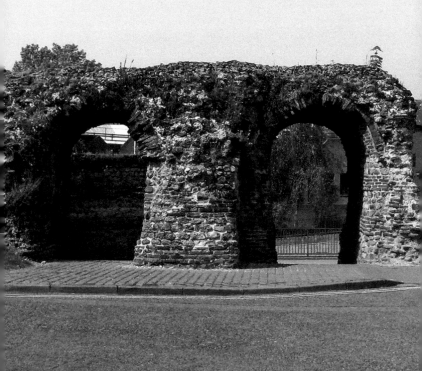

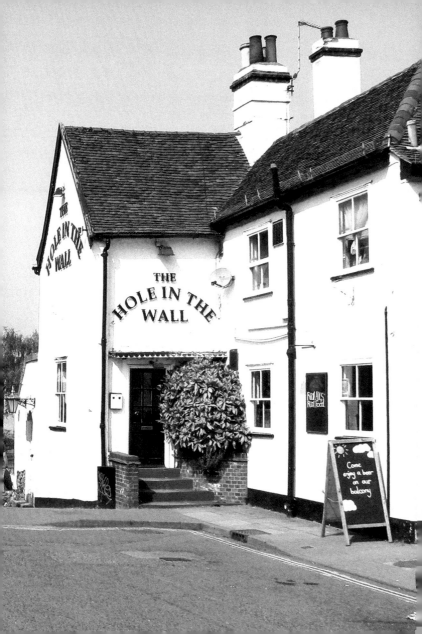

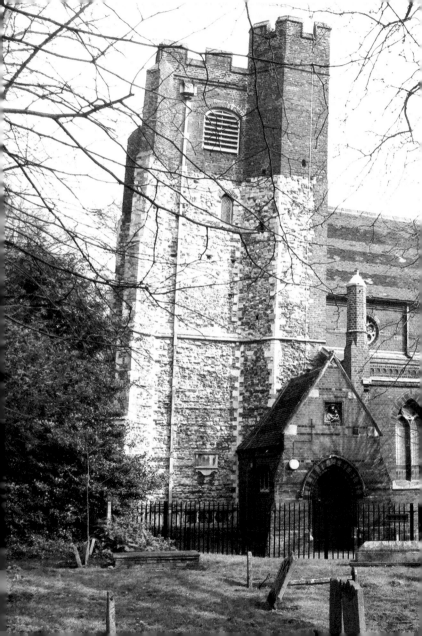

31. ST MARY'S AT THE WALLS

This church is medieval in origin and was one of many buildings damaged during the Siege of Colchester in 1648. Both the church and graveyard were used as a fort by the Royalist defenders, who managed to raise a small cannon to the top of the tower. This was eventually targeted by the Parliamentarian army, resulting in severe damage to the building and the demise of the marksman and his cannon. The church was rebuilt in the early eighteenth century, although the nave and chancel are Victorian. The building is now Colchester Arts Centre.

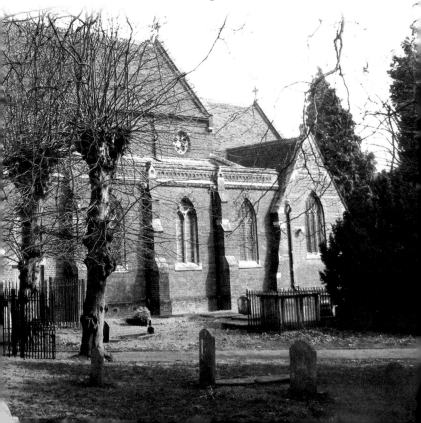

32. COLCHESTER'S FORMER POST OFFICE TOWER

The old post office building dominates this 1909 view of Head Street. The building was erected in 1874 and at the time was the tallest building in Colchester. In recent years the building has been converted into an Odeon multiplex cinema.

33. HEAD STREET LOOKING TOWARDS NORTH HILL

Head Street contains an interesting mix of old and new buildings. One building, however, that combines both old and new features is the fine-looking Georgian brick building seen on the right. In its heyday this would have been one of the grandest houses in town, and although the frontage still contains much of its original character, the entire front was demolished and rebuilt in the 1980s. The building is currently an H&M store.

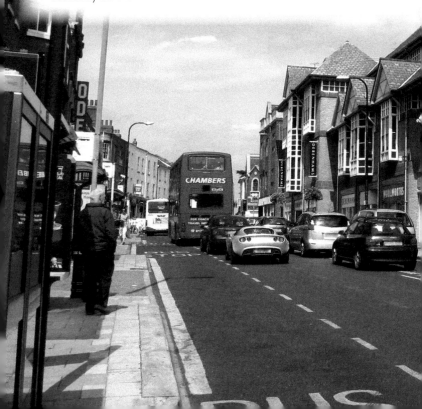

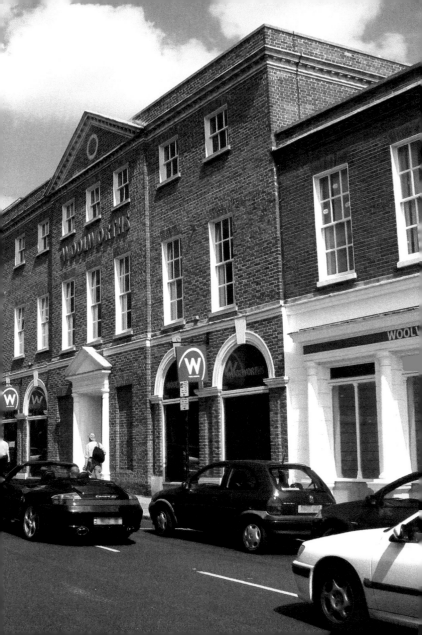

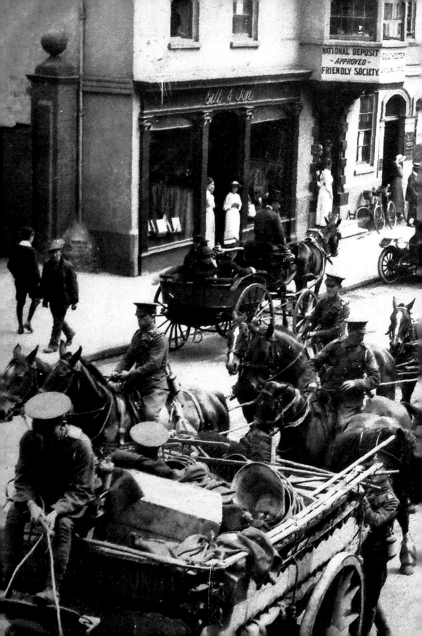

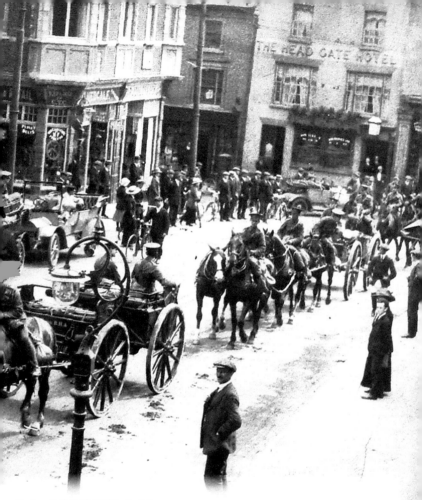

34. SOLDIERS IN HEAD STREET

Troops arriving in Head Street around the time of the First World War.
Note the occupants of the two open-top cars and the horse-drawn trap
parked up to take in the scene. A sizeable crowd has also gathered at
Headgate Corner.

35. THE BULL HOTEL, CROUCH STREET

This view of Crouch Street from 1926 is seen looking towards Headgate Corner with the Bull Commercial Hotel on the right. The inn is thought to date back to the fifteenth century and was a regular stopping place for stage wagons and carrier carts. Note the approaching tram, en route to Lexden, and the open-top car outside the hotel.

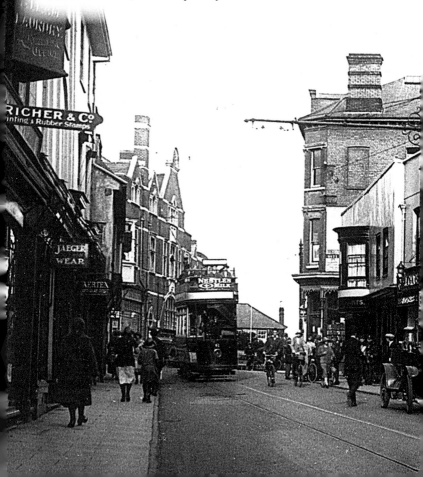

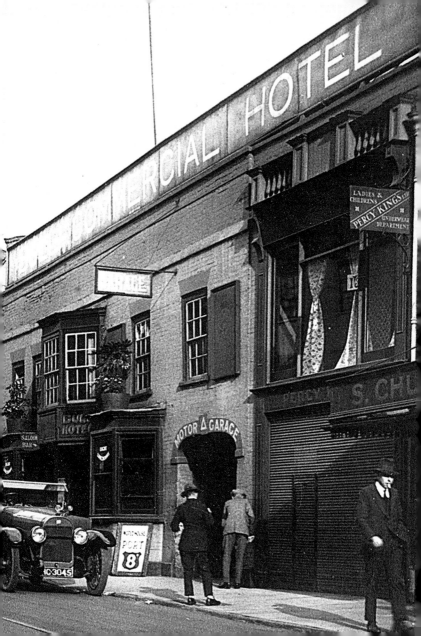

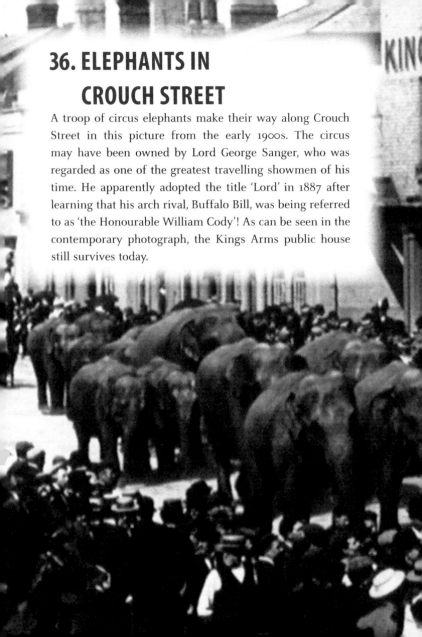

36. ELEPHANTS IN CROUCH STREET

A troop of circus elephants make their way along Crouch Street in this picture from the early 1900s. The circus may have been owned by Lord George Sanger, who was regarded as one of the greatest travelling showmen of his time. He apparently adopted the title 'Lord' in 1887 after learning that his arch rival, Buffalo Bill, was being referred to as 'the Honourable William Cody'! As can be seen in the contemporary photograph, the Kings Arms public house still survives today.

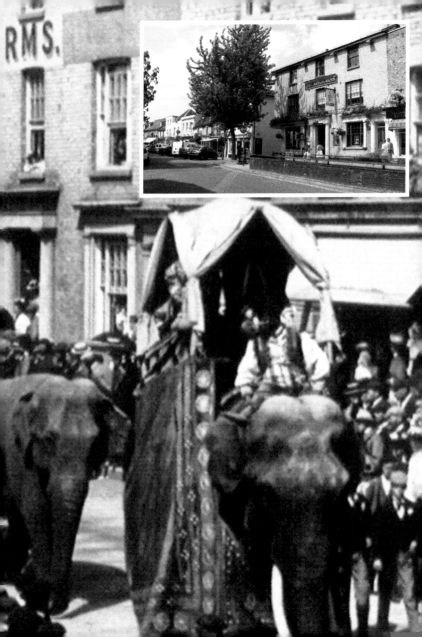

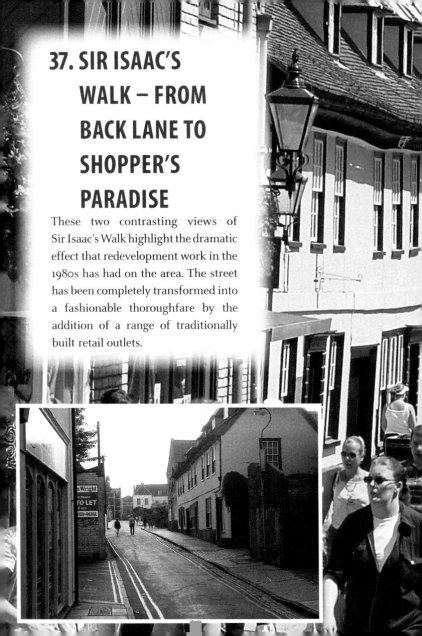

37. SIR ISAAC'S WALK – FROM BACK LANE TO SHOPPER'S PARADISE

These two contrasting views of Sir Isaac's Walk highlight the dramatic effect that redevelopment work in the 1980s has had on the area. The street has been completely transformed into a fashionable thoroughfare by the addition of a range of traditionally built retail outlets.

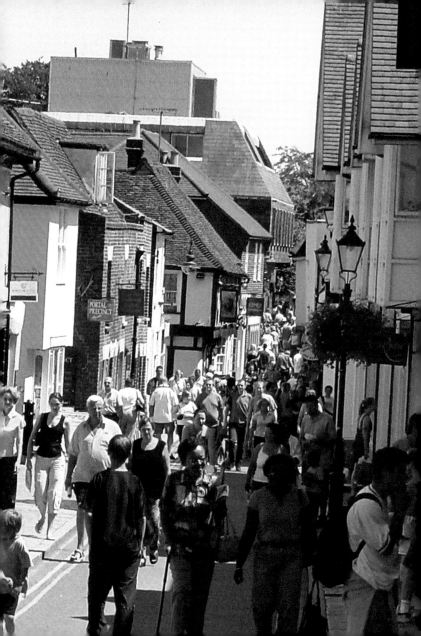

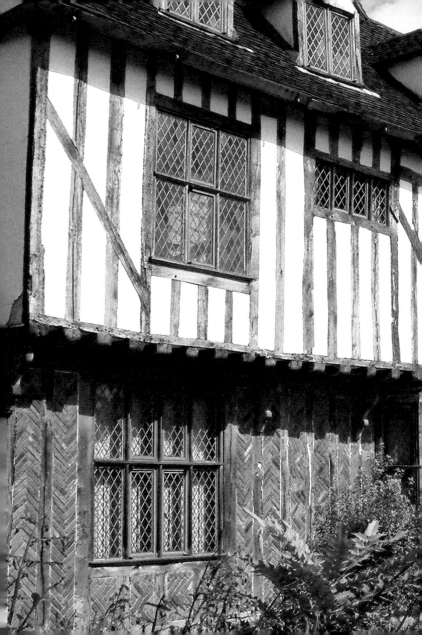

38. TYMPERLEYS

Tymperleys is part of the former home of Dr William Gilberd (1544–1603), a renowned scientist and physician to Queen Elizabeth I. He was a contemporary of such learned men as Galileo and Kepler and wrote an extensive treatise on magnetism entitled 'De Magnete'. In the early twentieth century Tymperleys was owned by a local industrialist named Bernard Mason who had a passion for collecting clocks that had been crafted by Colchester tradesmen. Before his death he gave the entire collection, as well as Tymperleys, to the borough.

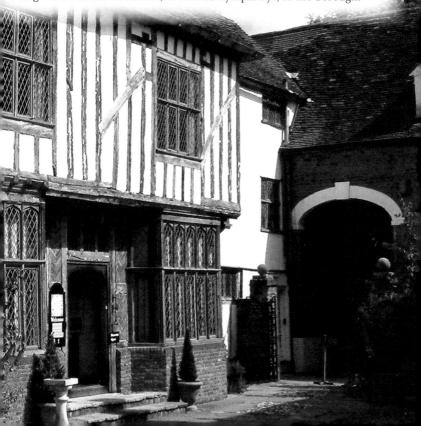

39. HOLY TRINITY CHURCH

The tower of Holy Trinity Church is the only Saxon monument still standing in Colchester. It dates from around 1000 and incorporates an interesting arrowhead doorway (see inset) comprised entirely of Roman bricks.

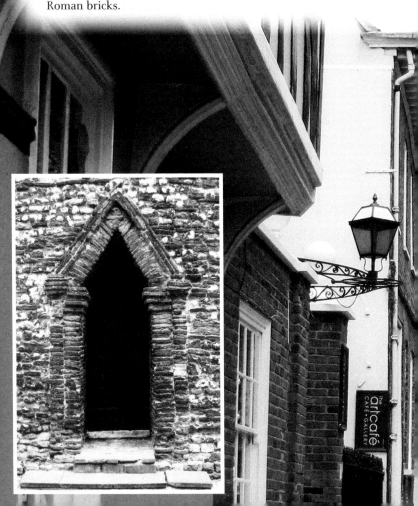

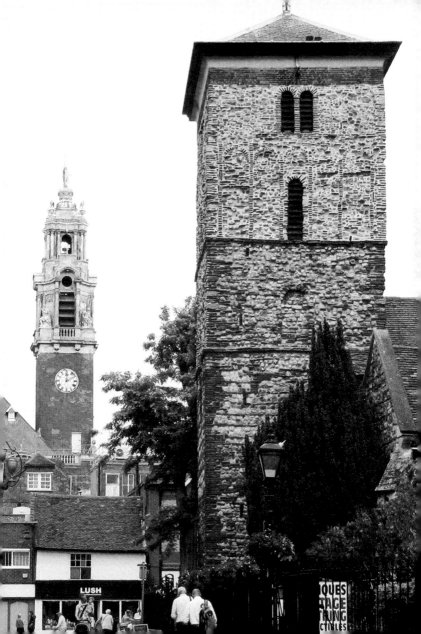

40. THE BREWERS ARMS

This charming view of St John's Street, taken from near the bottom of Scheregate Steps and looking towards the junction with Vineyard Street (left) and Osborne Street, appears to date from the late 1890s. The Brewers Arms, seen in the centre of the picture, has been trading as a public house since the early 1800s. In the modern view the Brewers Arms has changed very little over the intervening years.

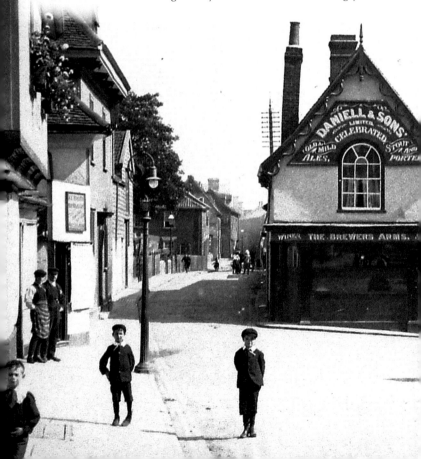

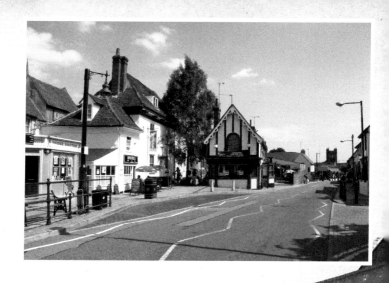

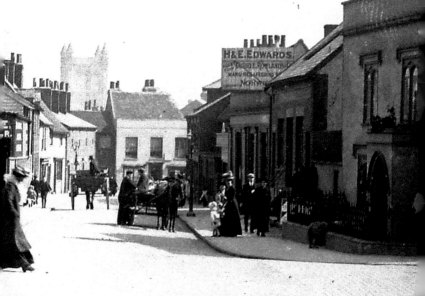

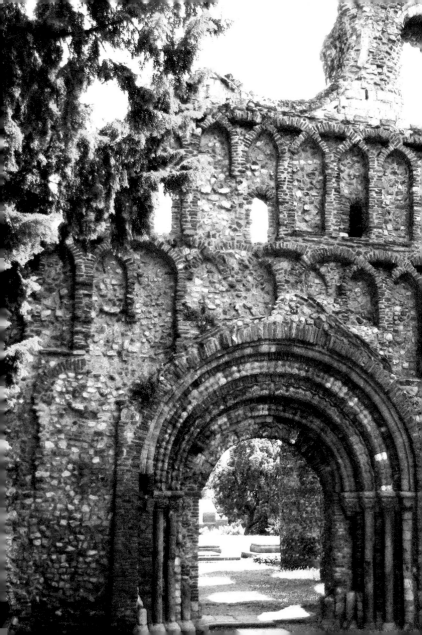

41. ST BOTOLPH'S PRIORY (WEST FRONT)

The picturesque ruins of St Botolph's Priory are all that remain of a house of Augustinian canons founded here around the year 1100. The surviving parts of the building include a section of the west front and part of the nave. The west front is dominated by the great west door, sometimes referred to as the 'Pardon Door', where at certain times of the year the public could bring their gifts to the priory and receive a pardon or absolution for their sins.

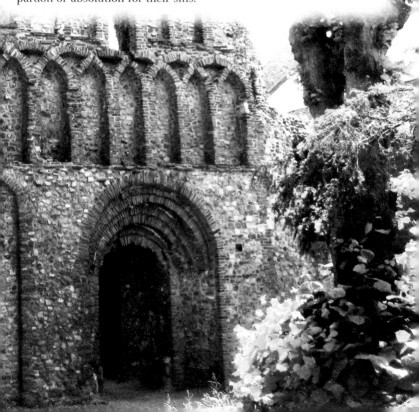

42. ST BOTOLPH'S PRIORY (NAVE AND AISLES)

Looking from the opposite direction we can see the impressive nave and triforium arcades, all built using recycled Roman brick and mixed rubble. There would also have been a third-storey arcade forming the clerestory, although this has not survived. Note also the large Norman-style cylindrical columns of the nave arcade.

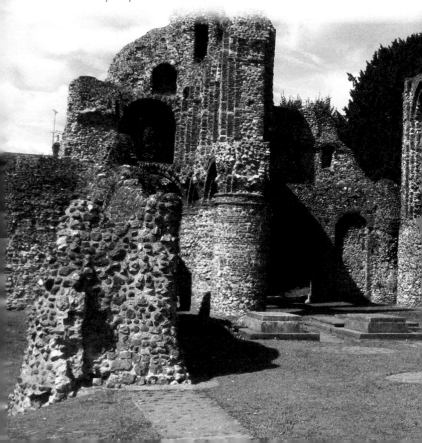

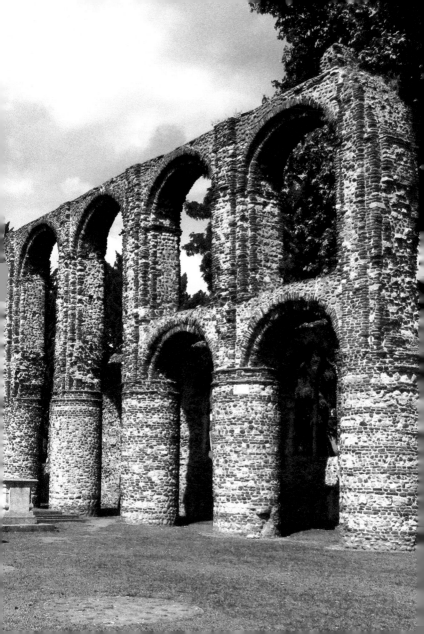

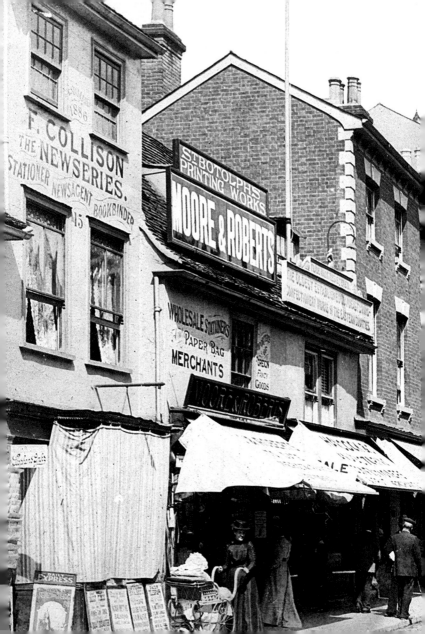

43. ST BOTOLPH'S STREET LOOKING NORTH

Several buildings in this street, including F. Collison's and Moore and Roberts' on the left, were destroyed during a night-time bombing raid in the Second World War. St Botolph's Street is still quite popular with shoppers, although plans are afoot to redevelop much of the area.

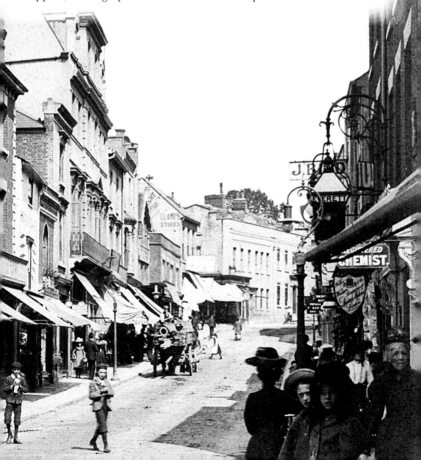

44. ST JOHN'S ABBEY GATEHOUSE

St John's Abbey gatehouse is all that remains of a large Benedictine abbey founded on this site in 1095. The gatehouse itself dates from the fifteenth century and today remains under the protection of English Heritage. In the older picture, dating from the early 1900s, the gatehouse stands at the top end of Stanwell Street and is flanked on either side by a row of houses and other buildings. Most of these buildings were demolished in the 1970s to make way for a new dual carriageway.

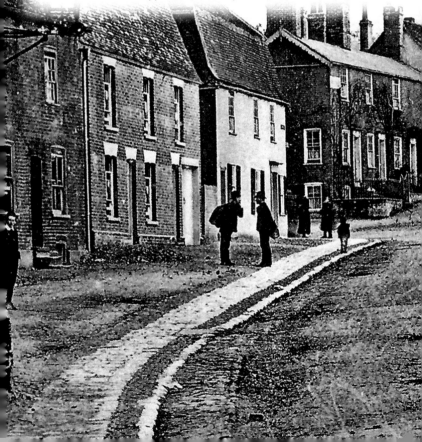

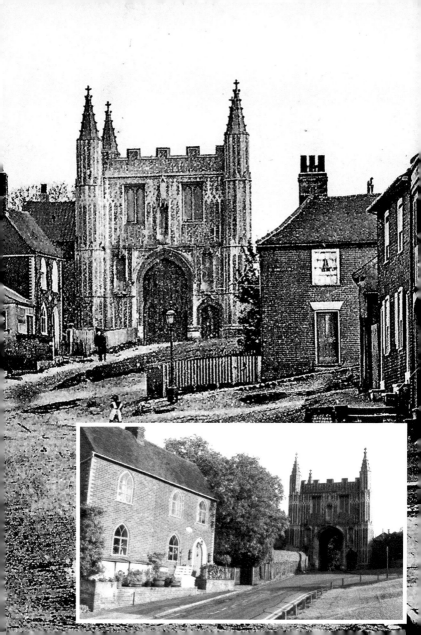

ACKNOWLEDGEMENTS

I am indebted to a number of people who have provided me with valued help and assistance in compiling this book, which is largely based on my previous title *Colchester Through Time*. Firstly, I would like to acknowledge the help received from the late David May, who generously provided me with free access to his large collection of local photographs, and also to Glen Jackson, who likewise made available some important archive photographs from his collection.